STRAWBERRIES

STRAWBERRIES

BY PAMELA ALLARDICE

ILLUSTRATIONS BY CATHERINE ROSE CROWTHER

CHRONICLE BOOKS SAN FRANCISCO

Library of Congress Cataloging-in-Publication Data

Allardice, Pamela.

 Strawberries / by Pamela Allardice; illustrated by Catherine Rose
 Crowther.

 p. cm.

 Includes index.

 ISBN 0-8118-0380-5

 1. Cookery (Strawberries) 2. Strawberries. I. Title.

TX813.S9A44 1993

641.6'475—dc20 92-28031

 CIP

Printed in Hong Kong.

Distributed in Canada by Raincoast Books, 112 East Third Ave.,
Vancouver, B.C. V5T 1C8

10 9 8 7 6 5 4 3 2 1

Chronicle Books
275 Fifth Street
San Francisco, CA 94103

CONTENTS

Strawberries in History

7

Strawberries in the Garden

11

Strawberries in the Kitchen

15

Soups and Compotes—19 Elegant Appetizers—25

Seductive Salads—30 Berries for Breakfast—35

Sweet and Savory Sauces and Relishes—39

Cakes and Tarts—45 Strawberries and Chocolate—54

Strawberry Preserves—58 Strawberry Drinks—61

Strawberries in the Bath

66

Index

70

Strawberries in History

"Doubtless God could have made a better berry, but doubtless God never did." So wrote William Butler some four hundred years ago of the strawberry—that most lauded of fruits and one of the oldest. Excavations of Swiss lakes have revealed strawberry seeds and fossilized berries dating from the Iron Age. The ancient Egyptians and Greeks left no record of strawberries. But in Roman times both Virgil and Ovid wrote of gathering *fragra*, the Old Latin name for strawberries and the root of its present generic name, *Fragaria*.

Historians, however, debate the source of the English word, *strawberry*. Some say the name evolved from the practice of stringing the berries on pieces of straw to carry them from the woods to the market. Others believe the name is derived from the Old English *streawberige*, so called because the plant's runners stray in all directions. From this sprang the term, "strawberry preachers," coined during the Middle Ages for traveling country clergymen who returned to their own parishes only once a year.

Regardless of how they were named, the large luscious berries we know today are a product of relatively recent times. Until the discovery of the New World, Europeans knew only the tiny wild woodland berry, *(F. vesca),* which the French call *fraise des bois.* Initially a favorite of country folk, strawberries came to enjoy royal favor as monarchs transplanted the wild berries to their gardens. In fourteenth-century France, Charles V ordered twelve hundred strawberry plants to be grown in the royal gardens of the Louvre. But another century passed before strawberries were cultivated in market gardens where they produced much larger fruit—up to twice the size of that growing in the wild.

Meanwhile, when the colonists arrived in North America, they found an abundance of berries of all kinds, but the small and extremely aromatic native strawberry (*F. virginiana*) was the finest of them all. Referring to the lush wild strawberry fields of Maryland, one early settler commented: "We cannot sett downe foote, but tred on Berries." The Native Americans called these fruits "heart-seed berries" and pounded them into their traditional cornmeal bread.

A century later, in 1712, a French naval engineer, ironically named Frézier (pronounced like the French word for "strawberry grower"), was sent to Chile to spy on the Spanish fortifications. There he encountered a large-flowered, large-fruited species of strawberry growing in the sands and carried some of the plants back to Brittany. They were officially named *F. chiloensis,* but dubbed "pineapple strawberry" due to their slight pineapple flavor. The Europeans cross-pollinated these Chilean beauties with the Virginia scarlets to produce the ancestor of our present large red hybrids.

By the nineteenth century, growers on both sides of the Atlantic were competing to breed a bigger and better strawberry. In England cultivation of the fruit reached its peak in the 1890s, when one Kentish grower alone had two thousand acres of strawberries! Gangs of workers picked berries in the middle of the night so the fruit could be at Covent Garden for morning sales. One firm claimed its strawberries were picked and made into jam the same morning and delivered for sale by midday.

Throughout history, strawberries have figured prominently in legend and lore, art and poetry. In the tradition of courtly love, strawberries were used as a decidedly flirtatious signal, meaning "you intoxicate me with delight" and "you are delicious." In art and literature, the strawberry was usually a symbol of sensuality and earthly desire. The fruit was regarded as an aphrodisiac of the highest quality, due to its prolific number of tiny "seeds." In fact, at wedding breakfasts in provincial France, newlyweds traditionally were served a soup of thinned sour cream, strawberries, borage, and powdered sugar.

In Norse mythology, the strawberry was believed to be the special fruit of the goddess Frigga, a patroness of matrimony. She gave the berries as a symbol to the spirits of young children who died in infancy—they ascended to heaven concealed in a strawberry.

Medieval artists portrayed the Virgin Mary with strawberries symbolizing perfection and righteousness. During the same period, stonemasons carved strawberry designs on altars and around the capitals of pillars in churches and cathedrals. Strawberries were served at important state occasions and festivals to ensure peace and prosperity. Perhaps it was this more reserved view of strawberries that gave them the meaning of "foresight" or "prudence" in the Victorian language of flowers. Poignantly, the gift of a whole plant came to mean that the recipient was held in high esteem, but—alas—not loved.

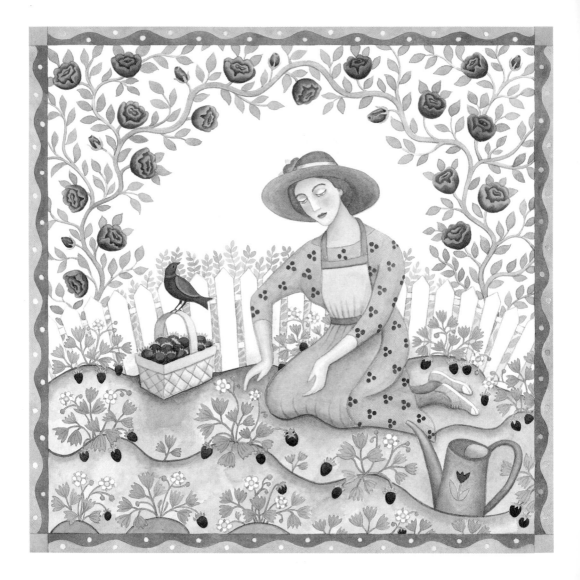

STRAWBERRIES IN THE GARDEN

Those baskets of berries in the market look lovely, but for flavor they can't compete with home-grown strawberries. Commercial growers harvest at a single time entire fields of berries with varying degrees of ripeness. But in your own garden, you can custom pick each berry just as it reaches its peak of sweetness and juiciness.

Starting a Strawberry Patch

Strawberries are herbaceous perennials suitable to all climates of North America and relatively easy to grow. Most varieties creep along the ground, sending out leafy runners in all directions. Clusters of dainty white flowers appear in late spring through early summer and berries usually appear from early summer to autumn, depending on the strain. If left untended, these leaf clusters will quickly put down roots and grow independently, thus forming new plants. This creates a handsome ground cover, which yields only a few tiny berries. If you are growing strawberries for their fruit, more care must be taken.

Numerous varieties of strawberries have been developed to adapt to various climates. Purchase from a reputable nursery disease-resistant plants especially recommended for your area. Varieties are usually classed as either "June bearing" or "everbearing." The June-bearing plants yield only one crop of fruit each summer, but their berries are generally considered to be superior to those of the everbearing plants, which produce fruit from early summer into the autumn. (A third type, the Alpine strawberry, produces tiny berries and no runners.)

Select a sunny site for your strawberry patch with loamy, well-drained soil. If drainage is a problem, build soil into mounds or ridges and set plants up high. They like soil to be rich, slightly acid, and well-mulched, so plenty of compost and decayed leaves should be worked

into the bed a few weeks before planting. In areas with very cold winters, strawberries should be planted in the spring. Otherwise the general rule is to plant strawberries in late summer or early winter, so as to harvest a crop of fruit the following summer. If you have planted in spring, the first flowers that appear should be pinched off, allowing the plant to conserve energy for fruiting the following year.

Plants should be set 12 to 20 inches apart, depending on whether root stock from runners is to be encouraged in the spaces in between. (Some gardeners cut off all runners to encourage the growth of larger berries; others allow some runners to root, producing more yet smaller berries.) If setting plants in rows, leave at least 2 to 3 feet between each so the plants have plenty of room to grow and space is still allowed for a "service path." Plants should be set just deep enough so the top of the crown is not covered. Water thoroughly after planting.

Nurturing Your Strawberry Bed

Strawberries should be watered with a good soaking once a week or more if the climate warrants it. The plants, however, should not be allowed to sit in water as mold is likely to grow on the berries. A good mulch or plastic covering helps to solve the moisture problem. Or do as "old wives" do. Mulch the beds with pine and spruce needles, crushed pinecones, and splintered twigs to emulate their natural woodland habitat.

Some gardeners say a weekly application of liquid fertilizer will work wonders on strawberries. But most recommend feeding the plants twice a year, in the spring and late summer. The first flowers of everbearing strawberies should be picked off to encourage a more prolific crop in late summer. From then on, flowers may be left on whenever they appear, producing fruit until the weather turns cold. In very cold climates, the plants should be given some protection in winter. The traditional method—of lightly covering the plants with straw—remains valid today.

Above all, protect your plants from pests and insects, such as aphids. If they attack, use a spray specifically recommended for vegetable crops and don't spray after the berries have formed. If you wish to keep your garden free of pesticides, spray with soapy water or a solution made from garlic and chili peppers. And don't forget that voracious aphids eater—the ladybug. Protection should also be provided from snails, slugs, mice, and birds. They all love strawberries, too. Strawberry plants tend to exhaust the ground in which they are planted. Every third year, you should prepare a fresh bed and replenish with new plants.

Growing Strawberries in Containers

Strawberries grown in pots and planters add a decorative note to decks and patios. Special terra-cotta or earthenware planters with little pockets in their sides allow the plants to trail and root. To set strawberries in these containers, first line the base with rocks or stones to facilitate drainage. Then gradually fill the container with a good-quality potting mix, forking through some compost as you go. When each opening in the container is reached, insert strawberry plants from the outside and fill the top of the container with them as well. Allow the runners to hang down and root in the openings. Plants in pots need more frequent watering than those in the garden. The little pockets are notorious for drying out rapidly.

Companion Planting

The effectiveness of planting certain herbs and plants next to each other has been recognized throughout history. Strawberries thrive when set near pyrethrum (painted daisy), which is well known as an insect repellent. Companion planting of strawberries with lavender is also recommended to deter birds during the fruiting season. "Old wives" say strawberry runners put forth larger fruit when borage is planted nearby. Strawberries also like to be close to beans, lettuce, and spinach. But they turn away from soil where cabbages are planted. And they will not be happy if strong-scented rosemary, mint, or thyme are too close. Gladioli are the kiss of death for strawberries—they will die from their effect, even if they are planted at opposite ends of the garden.

Strawberries in the Kitchen

When selecting strawberries to eat, choose those with a full red color and very little white or green. The flesh should be firm with a bright, shiny luster. Extremely large strawberries and small nuggety ones usually lack flavor, but since flavor and size vary from one species to another, this may not be an indicator. Consider yourself lucky if your market sells strawberries in bulk instead of baskets, so you can pick and choose the best. The "pint" baskets vary in weight from 12 to 16 ounces. Recipes in this book are based on a 12-ounce basket and the following equivalents.

12-ounce basket = about 3¼ cups whole strawberries
12-ounce basket = about 2¼ cups sliced strawberries
12-ounce basket = about 1½ cups puréed strawberries

Strawberries are very perishable and should be used as soon as possible after they're picked or purchased. Remove the top or plastic wrap from the basket and store berries in the refrigerator. Do not wash berries until you are ready to use them. Strawberries are a delicate fruit, so unless they are very muddy, don't sluice them under the cold-water tap; this might bruise them. Instead, clean them by gently dropping the berries into a basin of cold water or wipe them with a damp cloth to remove dust or grit. Hull berries *after* you have cleaned them, using a small blunt knife or the special strawberry hullers sold in some cookware shops. Freezing whole strawberries is not really satisfactory. It is preferable to halve, slice, or purée them before freezing.

Fresh strawberries may be used in many ways—in fruit salads or compotes; in desserts, ice-cream or between-course sorbets; in mousses, pies, tarts, cakes, jellies, glazes, jams, and

sauces. Strawberry purists aver that this fruit of paradise is perfect without any embellishment. But I find them a versatile fruit, which marries well with most condiments—cinnamon, cardamom, lemon and orange juices, brandy and other liqueurs, cloves, mace, mint, even black pepper! Are they at their best dipped in natural yogurt and dusted with allspice? Or sprinkled with powdered sugar and dunked in honey?

Serving Suggestions for Strawberries

 Arrange unhulled strawberries around two bowls for dipping. In one bowl place a scoop of sour cream and a mound of brown sugar. Fill the other bowl with fluffy cream cheese, whisked with orange juice and lemon zest.

Sprinkle cherry brandy over a bowl of whole, hulled strawberries. Pour over them a mixture of ⅔ cup sour cream and ⅓ cup whipping cream. Garnish with chopped pistachio nuts.

For a colorful compote, toss together halved strawberries, sliced peaches, and diced mangoes. Pour sweet sauterne over them and chill well.

Toss together halved strawberries, cantaloupe balls, and freshly squeezed lemon juice. Chill, arrange in cups of butter lettuce, and sprinkle liberally with freshly ground black pepper.

Pour crème de menthe over strawberries and dust thoroughly with confectioners' sugar. Chill for an hour and serve with passionfruit pulp.

Place a thick layer of caramel ice cream on the bottom of a bowl. Arrange very ripe strawberries on top and cover with sweetened strawberry purée.

Arrange strawberries in a pretty china bowl. Dredge with confectioners' sugar and pour over them freshly squeezed orange juice. Chill well.

For a wholesome breakfast, purée a basket of strawberries with 1 tablespoon honey. Arrange scoops of ricotta cheese in individual serving dishes, pour purée over them, and garnish with whole berries.

Fill pockets of pita bread with a mixture of sliced strawberries and cottage cheese seasoned with ground allspice and vanilla extract.

For a dessert sauce, combine mashed strawberries with plain yogurt, honey, and freshly grated nutmeg.

Place strawberries in wine glasses with slivers of honeydew melon. Fill glasses with chilled rosé wine or ginger ale.

To make pretty ice cubes for summer drinks, place a whole unhulled strawberry in each section of an ice-cube tray. Fill with pink-tinted water and freeze.

Combine 1 cup strawberry purée with ⅔ cup cream and add sugar to taste. Process in a blender until thick and smooth. Serve well chilled in tall glasses garnished with sliced strawberries.

For a summer garden party, chill wine and pour into a crystal pitcher. Garnish with sliced oranges, sliced strawberries, and a posy of woodruff.

Soups and Compotes

Strawberry Borscht

Most people identify borscht with beets. I call this soup "borscht" because of its distinctive red color. Serve before a meal or tote to a picnic in a thermal container.

2 cups puréed fresh strawberries
1¼ cups water
¼ cup dry red wine
Juice and grated zest of 1 lemon
Crushed ice
Sea salt, to taste
Sour cream, for garnish

In a food processor or a large bowl, thoroughly blend together strawberries, water, wine, lemon juice, and zest. Chill well. To serve, stir 1 tablespoon crushed ice through each portion, season well with sea salt, and decorate with a swirl of sour cream.

Serves 4 to 6

Strawberry Buttermilk Soup

This tart soup makes a lovely prelude for a sit-down brunch.

16 to 20 ounces fresh strawberries, hulled
2 cups water
1/2 cup buttermilk
1/2 cup freshly squeezed orange juice
Juice of 2 lemons
1 tablespoon chopped fresh mint
1/4 cup brown sugar (optional)
4 to 6 tablespoons plain yogurt
Mint sprigs, for garnish

In a stainless-steel or enameled saucepan, combine strawberries, water, buttermilk, orange juice, lemon juice, chopped mint, and sugar. Bring to a boil, reduce heat, and simmer gently for 10 minutes. Cool slightly, purée in a blender or food processor, and chill thoroughly. Before serving, swirl 1 tablespoon yogurt through each portion and garnish with mint sprigs.

Serves 4 to 6

Strawberry Ambrosia Compote

This fruit compote could double as a brunch starter or as a dessert. Or take it to a picnic. This is actually more fragrant and refreshing when served at room temperature, so remove from refrigerator about an hour before serving.

1 small honeydew melon
12 ounces fresh strawberries, hulled
1/2 pound seedless green grapes
2 1/2 cups white wine
2 tablespoons honey
1/2 cup rose water

Remove seeds from melon and scoop out flesh with a melon baller. In a bowl, combine melon balls with strawberries and grapes. In another bowl, stir together wine, honey, and rose water and pour over fruit. Chill for several hours.

Serves 4 to 6

Fruits of Paradise Compote

Here's another compote for launching a festive brunch or ending a dinner. If you like, serve with a pitcher of thick cream.

16 to 20 ounces fresh strawberries, hulled
2 tablespoons brandy
1 tablespoon brown sugar
2 teaspoons freshly squeezed lemon juice
Slivered almonds, toasted, for garnish

In a chilled bowl, gently toss strawberries with brandy, sugar, and lemon juice. Chill well. To serve, spoon into glass bowls or long-stemmed glasses and garnish with almonds.

Serves 4 to 6

ELEGANT APPETIZERS

❦

Curly locks, curly locks, wilt thou be mine?
Thou shalt not wash dishes,
nor yet feed the swine,
But sit on a fine cushion and sew a fine seam
And feed upon strawberries, sugar and cream.
—Traditional

Grilled Strawberry Kebabs

Serve these skewers of grilled fruit as a first course for brunch or as an accompaniment to grilled chicken or pork chops.

8 to 10 ounces large fresh strawberries,
 hulled

1 red-skinned apple, unpeeled, cored,
 and cubed

1 can (11 ounces) mandarin orange
 segments, drained

1 banana, peeled and thinly sliced

1/2 cantaloupe or honeydew melon,
 scooped into balls

Fresh pineapple wedges

Glaze

1 tablespoon cornstarch

Juice of 1 lemon

1/3 cup freshly squeezed orange juice

2 tablespoons honey

Ground cinnamon, to taste

2 to 3 teaspoons finely chopped fresh mint

Thread fruit on long metal skewers. In a small stainless-steel or enameled saucepan, dissolve cornstarch in lemon juice. Add remaining ingredients, except mint, and heat, stirring, until mixture thickens; then add mint. Paint fruit with glaze and broil or grill until fruit is cooked through and lightly browned. Serve immediately.

Serves 4 to 6

Strawberry Hearts

This is a take on coeur à la crème, *a classic French dessert devised by the great chef Carême and often accompanied with* fraises des bois. *Individual heart-shaped porcelain molds, about three inches wide, are available at specialty cookware shops. As a first course for brunch or lunch, serve with unsalted crackers, melba toast, or small slices of pumpernickel.*

8 ounces cream cheese
2 tablespoons confectioners' sugar
1 teaspoon vanilla extract
Pinch salt
⅔ cup sour cream
⅓ cup whipping cream, whipped
1 egg white
6 perfect strawberries, with stems intact

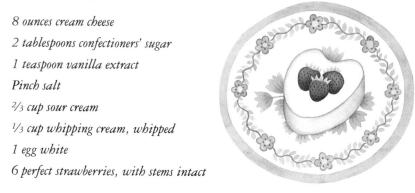

In a chilled bowl, beat together cream cheese, sugar, vanilla, and salt. In another bowl, mix together sour cream and whipped cream. In a third bowl, beat egg white until frothy. Fold egg white into whipped-cream mixture and gently fold into cream cheese mixture. Line 6 heart-shaped molds with damp cheesecloth or plastic wrap and press mixture into them. Chill overnight. To serve, invert onto individual plates and garnish with strawberries, either whole, sliced, or cut into decorative fans.

Serves 6

Savory Strawberry Mousse

Serve this tart cheesy mousse with sliced peaches and melba toast before brunch or as a teatime treat. If you rinse a ring mold with cold water and chill it before filling, it's easier to unmold later.

1 cup puréed fresh strawberries

1/2 pint small-curd cottage cheese

2/3 cup plain yogurt

Grated zest and juice of 1/2 lemon

2 tablespoons water

2 envelopes (1/4 ounce each) unflavored gelatin

2 egg whites

3 peaches, peeled, sliced, and dipped into lemon juice

Unstemmed whole strawberries, for garnish

Thin slices melba toast

In a large bowl, combine strawberry purée, cottage cheese, yogurt, and lemon zest and mix well. In a small saucepan, combine lemon juice with the water and sprinkle with gelatin; let sit 1 minute. Over low heat, stir mixture until gelatin is dissolved completely and immediately stir gelatin into strawberry mixture. In another bowl, beat egg whites until stiff and fold them into the strawberry mixture. Spoon into a rinsed and chilled 3-cup ring mold, cover, and refrigerate until set, about 4 hours.

To serve, dip mold into hot water for 10 seconds, cover with a serving plate, and invert. Heap peaches and whole strawberries in the center of the ring and arrange melba toast around it.

Serves 4 to 6

SEDUCTIVE SALADS

Strawberry and Rosé Ring

This rosy molded salad, laden with strawberries and other fruits, makes a handsome addition to a buffet table. Use a varietal rosé with good character and color, such as zinfandel, not the pale pink generic wines.

1/3 cup sugar

2 envelopes (1/4 ounce each) unflavored
 gelatin

1 3/4 cups boiling water

1 3/4 cups rosé wine

1 teaspoon grated lemon zest

2 tablespoons freshly squeezed lemon juice

12 ounces fresh strawberries, hulled
 and halved

1/2 cup diced unpeeled red-skinned apple

1/2 cup chopped dates

1/2 cup finely diced celery

1/2 cup diced mandarin orange segments

1/4 cup diced grapefruit segments

In a large bowl, mix together sugar and gelatin, pour the boiling water over them, and stir well to dissolve sugar and gelatin. Add wine, lemon zest, and lemon juice. Chill until syrupy. In another bowl, mix together strawberries, apple, dates, celery, mandarin oranges, and grapefruit and gently stir them into the jelled mixture. Pour into a rinsed and chilled 6-cup ring mold, cover, and refrigerate until set, about 4 hours. To unmold, dip the mold into hot water for a few seconds and then invert it onto a chilled glass plate.

Serves 6 to 8

Strawberry and Pansy Salad

Pansies and violets not only make decorative garnishes for salads, they are a source of vitamins A and C. Be sure to gather the blossoms from a garden that has not been sprayed with pesticides.

Red oakleaf lettuce, torn into
 bite-sized pieces
12 ounces small fresh strawberries, hulled
10 snow peas
1 stalk celery, finely chopped
1 mango, peeled and sliced
1 handful pansy blossoms, gently rinsed

Hazelnut Dressing

2 tablespoons hazelnut oil
1 tablespoon apple cider vinegar
1 tablespoon freshly squeezed lemon juice
1 tablespoon finely minced hazelnuts
Freshly ground black pepper, to taste

In a salad bowl, combine all ingredients, except dressing. In a small bowl, mix together dressing ingredients. Toss dressing through salad gently, so as not to bruise flowers, and serve immediately.

Serves 4 to 6

Strawberry and Feta Cheese Salad

Tart feta and sweet strawberries are bound with a creamy mustard dressing in this red, white, and green salad.

½ cauliflower, broken into florets
12 ounces small fresh strawberries, hulled
1 bunch watercress, stems cut off
4 ounces feta cheese, crumbled into chunks

Dressing

2 tablespoons apple cider vinegar
3 tablespoons olive oil
2 tablespoons whipping cream
1 teaspoon Dijon-style mustard
Salt and freshly ground black pepper,
to taste

Blanch cauliflower by cooking the florets in boiling water for 1 minute and draining. In a salad bowl, gently mix together florets with strawberries, watercress, and feta. In a lidded jar, combine all dressing ingredients and shake well. Drizzle dressing over salad and serve immediately.

Serves 4 to 6

BERRIES FOR BREAKFAST

Strawberry Bagels

All the components of a well-balanced breakfast are right here. Just brew a pot of coffee and you're ready to start the day.

6 bagels, split in half and toasted

6 ounces cream cheese or Neufchâtel cheese

12 ounces fresh strawberries, hulled and
 thinly sliced lengthwise

2 to 3 tablespoons honey

Ground cinnamon, to taste

Spread warm bagel halves with cheese. Toss berries in honey and arrange on top of cheese. Dust with cinnamon and serve immediately.

Serves 6

Sweet Strawberry Omelet

Here's breakfast for two or even a late-night supper.

4 eggs
1 tablespoon superfine sugar
1 tablespoon half-and-half
Pinch salt
Butter, for cooking
4 to 5 ounces fresh strawberries,
* hulled and sliced lengthwise*

In a bowl, beat together eggs, sugar, half-and-half, and salt until frothy. In a small skillet, heat enough butter to cover pan, pour in half of the egg mixture, and reduce heat slightly. When the eggs are cooked through, spread half the strawberries on one side of the omelet, fold it in half, and serve at once. Repeat the process for the second omelet.

Serves 2

SWEET AND SAVORY SAUCES AND RELISHES

❧

According to ancient zodiacal lore,
strawberries are ruled by the symbol of balance,
Libra, and come under the domination
of Venus, who favors plants with especially
pretty flowers and who also enjoys nibbling
upon rosy fruits.

Orange Strawberry Sauce

This is especially tasty on pancakes and waffles, but would be good on ice cream, too.

16 to 20 ounces fresh strawberries, hulled
1 tablespoon freshly squeezed orange juice
1 tablespoon blackberry jam
1 tablespoon superfine sugar

1 tablespoon Cointreau or other
* orange liqueur*
Dash crème de cacao
Grated zest of ½ orange and ½ lemon

In a blender or food processor, blend all ingredients except zest until smooth. Sprinkle the pancakes, waffles, or ice cream with the zest and serve the sauce in a pitcher or bowl.

Makes about 2 cups

Strawberry Rhubarb Sauce

An especially good topping for vanilla ice cream.

1 pound rhubarb, diced

¾ cup sugar

¼ teaspoon salt

12 ounces fresh strawberries, hulled
 and halved

2 tablespoons butter

2 teaspoons grated lemon zest

In a medium saucepan, combine rhubarb, sugar, salt, and water to cover. Place over low heat and stir occasionally until sugar dissolves and water boils. Simmer for 10 minutes. Stir in strawberries and simmer until fruit softens, about 10 minutes. Remove from heat and stir in butter and zest. Cool slightly before serving.

Makes about 2 cups

❦

To find two strawberries growing as one
near a house indicates twins will be born
soon in a nearby family.

Strawberry Barbecue Sauce

This unusual sauce goes very well with grilled chicken and barbecued meats, such as spareribs. You may use any strawberry jam, but the Strawberry and Red Currant Jam is especially good.

1¼ cups strawberry jam
¾ cup tomato sauce
1 tablespoon Worcestershire sauce
1 onion, minced
Freshly ground black pepper, to taste
1 tablespoon honey
1 teaspoon minced fresh ginger root

Combine all ingredients in a stainless-steel or enameled saucepan. Stirring constantly with a metal spoon, bring mixture to a boil, reduce heat, and simmer for 5 minutes, adding a little water if sauce becomes too thick.

Makes about 2 cups

Jellied Strawberry Relish

Here's a bright accent for meats, salads, or sandwiches. And it's easy to prepare.

2 envelopes (1/4 ounce each) unflavored
 gelatin
2/3 cup cold water
2/3 cup port wine, heated
Sugar, to taste
1 medium orange, peeled, seeded,
 and chopped
16 to 20 ounces fresh strawberries, hulled
2/3 cup coarsely chopped walnuts

In a blender container, sprinkle gelatin over water and let sit 1 minute. Pour heated port wine onto gelatin mixture and process at low speed until gelatin dissolves. Add sugar, orange, and strawberries and blend until puréed. Gently stir in walnuts. Decant into pretty glass serving dishes, cover, and chill until firm.

Makes 3 to 4 cups

CAKES AND TARTS

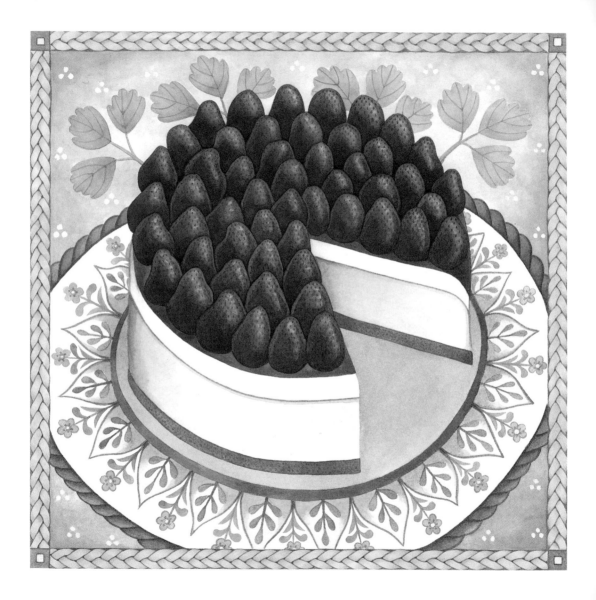

Strawberry Cheesecake

A lemony cheesecake with a hazelnut crust, topped with strawberries and apricot jam. A great dessert, but why not try it for breakfast?

Hazelnut Crust (following)

16 ounces cream cheese, softened

⅔ cup superfine sugar

2 eggs, separated

2 teaspoons grated lemon zest

1 tablespoon freshly squeezed lemon juice

1¼ cups sour cream

1 tablespoon brown sugar

1 teaspoon vanilla extract

12 ounces fresh strawberries, hulled

⅔ cup apricot jam

Preheat oven to 350°F and prepare Hazelnut Crust. In a large bowl, combine cream cheese, sugar, egg yolks, lemon zest, and lemon juice; beat until creamy. In another bowl, beat egg whites until stiff peaks form. Gently fold egg whites into cream cheese mixture and pour into prepared crust. Bake until the filling is set and firm, about 20 minutes. Allow to cool.

In a small bowl, beat sour cream, sugar, and vanilla until sugar dissolves. Spread over cooled cheesecake and place berries upright on top. In a small saucepan, heat jam, press through a sieve, and carefully brush over berries. Chill well before serving.

Serves 6 to 8 ▶

Hazelnut Crust

1½ tablespoons butter, softened

1 cup crushed zwieback

⅔ cup ground hazelnuts

1 teaspoon finely grated orange zest

In a bowl, combine all ingredients and mix well. Press into the base of a 9- to 10-inch pie plate or tart pan.

Makes one 9- to 10-inch crust

❁

The witty and delightful Anne Boleyn had a
strawberry-shaped birthmark on her
slender neck—to her eventual dismay.
Her enemies said this mark was
sure evidence that the
queen was a witch.

Strawberry and Yogurt Tart

Any prepared tart shell may be used for this recipe instead of the Hazelnut Crust.

Hazelnut Crust (preceding)
*12 to 16 ounces fresh strawberries, hulled
 and halved*
Pinch each ground nutmeg and cinnamon
2 tablespoons honey
½ pint plain yogurt
6 ounces cream cheese, softened
Vanilla extract, to taste
Pistachio nuts, for garnish
*Whipped cream or ice cream,
 for accompaniment*

Prepare Hazelnut Crust. Reserve some of the sliced strawberries for garnish. Cover the base of the crust with remaining berries, sprinkle with nutmeg and cinnamon, and drizzle with honey. In a bowl, combine yogurt and cream cheese, blend thoroughly, and season with vanilla extract. Spoon yogurt mixture over strawberries and garnish with reserved berries. Chill well and serve with whipped cream or ice cream.

Serves 6 to 8

Fluffy Strawberry Soufflé

This is not a true soufflé, but it looks like one. Note that it must chill overnight.

16 to 20 ounces fresh strawberries, hulled

2 envelopes (¼ ounce each) unflavored gelatin

1¼ cups sugar

6 eggs, separated

1 tablespoon freshly squeezed lemon juice

Pinch salt

1¼ cups whipping cream

Set aside 6 to 8 of the prettiest berries for garnish and purée the remaining berries to make about 2 cups purée. In a heavy saucepan, combine gelatin, ¾ cup of the sugar, and the egg yolks. Over very low heat gradually add puréed strawberries and continue stirring until mixture thickens. Remove from heat, stir in lemon juice, and allow to cool.

In a large bowl, beat egg whites with salt and remaining ½ cup sugar until shiny stiff peaks are formed. In another bowl, whip cream until it forms soft peaks and fold into egg whites. Very gently fold in strawberry purée. Spoon mixture into a serving dish, mounding it high to form a "soufflé" appearance. Chill overnight. Before serving, garnish soufflé with reserved berries.

Serves 6 to 8

Strawberry and Pistachio Whip

Served in parfait glasses, this is an elegant dessert. If you don't have parfait glasses, large wine glasses are stunning, too.

1 envelope (¼ ounce) unflavored gelatin
⅔ cup milk
2 eggs, separated
⅓ cup brown sugar
1 tablespoon hot water

1¼ cups puréed fresh strawberries
2 to 3 tablespoons kirsch
1¼ cups whipping cream
2 tablespoons superfine sugar
⅔ cup finely chopped pistachio nuts
4 to 6 whole strawberries, for garnish

In a small saucepan, sprinkle gelatin over milk and let sit for 1 minute. Over low heat, stir milk to dissolve gelatin and let cool. In a large bowl, beat egg yolks with brown sugar and water until foamy. Continue beating and gradually add puréed berries, kirsch, and finally, cooled gelatin mixture. Chill for ½ hour.

In a large bowl, beat cream with superfine sugar until soft peaks form. Reserve about ¾ cup of the whipped cream for decoration and fold the rest into strawberry mixture, along with chopped nuts. To serve, spoon into parfait glasses. Pipe the reserved whipped cream in a rosette on each dessert and top with a whole strawberry.

Serves 4 to 6

Strawberry Crème Brûlée

Crème brûlée (burnt cream) is not French at all, but a dessert invented at King's College, Cambridge, in seventeenth-century England. Here's an unorthodox strawberry version.

12 ounces fresh strawberries, hulled

2 tablespoons superfine sugar

3 tablespoons kirsch

²/₃ cup sour cream

²/₃ cup whipping cream

Brown sugar, for topping

In a bowl, toss together strawberries, sugar, and kirsch; let stand for 1 hour. Spoon portions of berry mixture into 6 individual ovenproof dessert dishes or ramekins. Whip together sour cream and whipping cream and spread over the strawberries. Sprinkle with brown sugar and place under a preheated broiler until the sugar caramelizes. Serve immediately.

Serves 6

Strawberry Gelato

This can be served as a dessert or, like a sorbet, as a palate refresher between courses at a formal dinner.

1 cup sugar

1⅓ cups water

3 cups puréed fresh strawberries

2 tablespoons grated lime zest

2 tablespoons freshly squeezed lime juice

1 tablespoon freshly squeezed orange juice

In a small saucepan, heat sugar and water until sugar is dissolved; allow to cool. In a bowl, combine strawberry purée with zest, lime juice, orange juice, and cooled sugar syrup. Pour into a freezer container and chill until firm.

Makes about 1 quart

❀

In the Victorian language of flowers,
strawberries symbolize perfect excellence.

Strawberries and Chocolate

Chocolate-Dipped Strawberries

Delicious served with coffee after a meal or at tea time. Try to buy these strawberries in bulk, not baskets, to be sure they are perfect.

8 ounces dark semisweet or bittersweet
 baking chocolate

½ teaspoon safflower oil

1 teaspoon peppermint extract

12 to 16 large perfect strawberries,
 with stems intact

In the top of a double boiler over gently simmering water, stir together chocolate, oil, and peppermint until mixture is smooth and creamy. Hold each strawberry by the stem and dip it into the warm chocolate mixture to the "shoulder" of each berry. Place chocolate-covered berries stem side down on waxed paper and allow to set.

Makes 12 to 16 coated berries

❀

If a boy and girl break open
a double strawberry and each eats one half,
they will become sweethearts.

Strawberry and Chocolate Fondue

It's an old Swiss custom, when eating cheese fondue, that a young man gets a kiss if he knocks the bread cube off a young lady's fondue fork. Try this with strawberries and chocolate sauce instead.

⅔ cup sweetened condensed milk

8 ounces dark semisweet or bittersweet
 baking chocolate, grated

⅓ cup milk

2 teaspoons instant coffee

¼ cup brandy

16 ounces large fresh strawberries,
 with stems intact

In the top of a double boiler over gently simmering water, stir together condensed milk, chocolate, and milk until chocolate melts. Stir in coffee and brandy. Transfer to a fondue pot and serve warm, using whole strawberries to dip into the sauce.

Serves 4 to 6

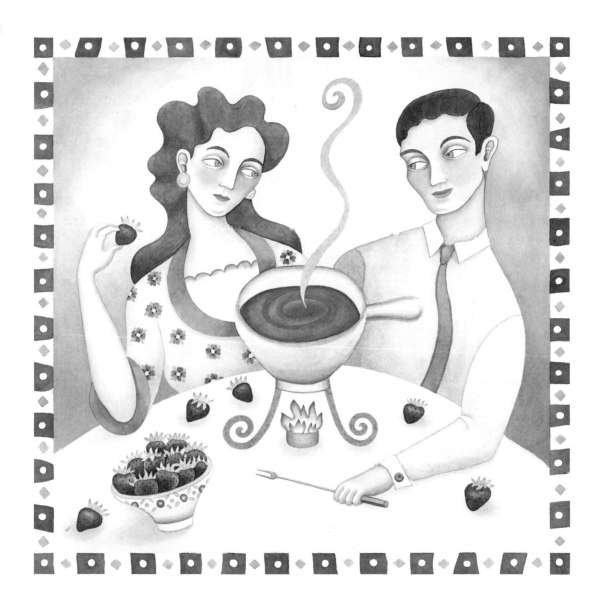

Strawberry Preserves

Strawberry, Rhubarb, and Raisin Jam

When making preserves, always use jars especially made for that purpose, check carefully that there are no nicks on the tops, and never reuse lids. An easy way to sterilize jars is to run them through the dishwasher and keep them hot until ready to use.

2½ cups fresh strawberries, hulled

2 cups diced rhubarb

1 cup seedless raisins

1 cup diced and seeded orange segments

½ cup orange zest strips

3 cups sugar

⅓ cup chopped walnuts

⅓ cup liquid pectin

In a large stainless-steel or enameled saucepan, combine strawberries, rhubarb, raisins, orange segments, zest, and sugar. Cover and set aside in a cool, dark place for 12 hours. Bring slowly to a boil and boil for 5 minutes, stirring constantly. Add walnuts and pectin and remove from heat. Skim off scum and continue stirring for 5 to 10 minutes to keep fruit in suspension. Ladle into hot sterilized jars to within ¼ inch from the top and seal with sterilized lids according to the manufacturer's instructions. Store in a cool, dark place.

Yields about eight ½ pint jars

Strawberry and Red Currant Jam

Its beautiful rosy color has made this jam a favorite at church and school bazaars.
For tips on making jams, see the preceding recipe.

1 pound red currants
Juice and grated zest of 1 orange
1 cup water
2 pounds fresh strawberries, hulled
3 pounds light brown sugar

In a large stainless-steel or enameled saucepan, combine currants, orange juice, and water. Bring to a boil, reduce heat, and simmer until currants are soft. Add strawberries and simmer another 5 minutes. Add sugar and zest and stir gently until sugar dissolves. Raise heat and boil rapidly until mixture thickens. Ladle hot mixture into hot sterilized jars, to within ¼ inch of the top. Seal with sterilized lids according to the manufacturer's instructions. Store in a cool, dark place.

Yields about four ½ pint jars

STRAWBERRY DRINKS

Strawberry and Yogurt Cooler

Refreshing at any time of the day, but also a lovely and nourishing breakfast drink.

4 to 5 ounces fresh strawberries, hulled
1 tangerine, peeled and sectioned
1 ripe banana, peeled and sliced
1 teaspoon chopped fresh mint
1/3 cup freshly squeezed orange juice
1/2 pint plain yogurt

Reserve a few strawberries and tangerine sections for garnish. Place remaining ingredients in a blender or food processor and blend until smooth. Pour into tall, chilled glasses and garnish with reserved strawberries and tangerine segments.

Serves 2

Strawberry Syllabub

Syllabubs—frothy milk punches—were popular with the early American settlers.

2 cups whipping cream
2 cups milk
1/2 cup sherry
1/4 cup sugar
Pinch salt
6 to 8 strawberries, hulled and sliced
Freshly grated nutmeg, for garnish

In a large bowl, beat together cream, milk, sherry, sugar, and salt until fluffy. Fold strawberries into mixture and pour into punch cups or small glasses. Top each serving with a sprinkling of nutmeg.

Serves 6

❧

The strawberry grows underneath the Nettle,
And wholesome berries thrive and ripen best
Neighbour'd by fruit of lesser quality.
—William Shakespeare, *Henry V*

Brandied Strawberry Punch

This festive punch combines melon, strawberries, and kiwis with white wine, champagne, and a dose of brandy.

1 small honeydew melon

12 ounces strawberries, hulled and halved

6 tablespoons superfine sugar

½ cup strawberry liqueur

5 to 6 tablespoons brandy

1 kiwifruit, peeled and thinly sliced

2 bottles (750 ml each) sweet white wine, chilled

1 bottle (750 ml) sparkling white wine, chilled

Halve and seed melon and scoop out flesh with a melon baller. Combine melon balls and strawberries in a large punch bowl. Sprinkle with sugar and toss gently. Add strawberry liqueur and brandy; cover and let stand 1 hour. Add kiwifruit, then slowly pour sweet wine into bowl; chill. Add sparkling wine just before serving.

Makes about 3 quarts

The Ultimate Strawberry Daiquiri

The daiquiri got its name shortly after the Spanish-American war, when a group of American engineers went to Cuba to develop the Daiquiri iron mines. They became fond of a local drink of rum, lime juice, and sugar and called it "daiquiri" after the mines.

4 to 5 ounces fresh strawberries, hulled
3 tablespoons white rum
2 tablespoons freshly squeezed lime juice
1 tablespoon pineapple juice
1 egg white
1 tablespoon strawberry liqueur
1 teaspoon ginger syrup
½ teaspoon maraschino syrup (optional)
Crushed ice

Reserve 2 strawberries for garnish. Combine remaining strawberries and all other ingredients except ice in a blender and blend at very low speed until smooth and frothy. Stir ice into mixture and serve immediately in 2 large, chilled wine glasses, each garnished with a strawberry.

Serves 2

Strawberries in the Bath

Throughout history, strawberries and their leaves have been touted for their medicinal and cosmetic benefits. Chewing the leaves for bleeding gums is a remedy that goes back to the time of Christ. Sixteenth-century herbalists credited various parts of the plant with benefits ranging from whitening the teeth to relieving sore throats to removing freckles. During the Napoleonic era, Madame Tallien supposedly added the juice from twenty pounds of crushed strawberries to her bath in order to soften her skin. Following are some remedies made from strawberries that work as a beauty aid and to relieve minor aches and pains.

A fragrant infusion of 2 ounces of well-dried strawberry leaves to 1 cup boiling water, steeped for 30 minutes, will help contract open pores and counter an oily skin condition. A stronger infusion will produce a lightly perfumed toilet water.

To whiten teeth and remove tartar, paint teeth with strawberry juice, leave on for 5 minutes, and rinse with warm water.

A cut strawberry rubbed over the face will whiten the skin. Combined with honey, strawberry juice will reduce inflammation or sunburn; rub the mixture thoroughly into the skin before rinsing off with warm water and lemon juice.

Freshly sliced strawberries are a simple and effective revitalizer for all skin types. Cut them lengthwise, place a layer of strawberry slices over your face, and lie down for 10 to 15 minutes. Rinse them off with sparkling mineral water before applying moisturizer.

For a rich nourishing skin cream, beat together 2 tablespoons of whipping cream and 1 tablespoon of strawberry juice.

Fresh juice from sieved strawberry pulp has a cooling effect on feverish patients. Pour water on crushed berries for a cooling and purifying drink. Or chop the berries roughly and whirl in a blender with a little water.

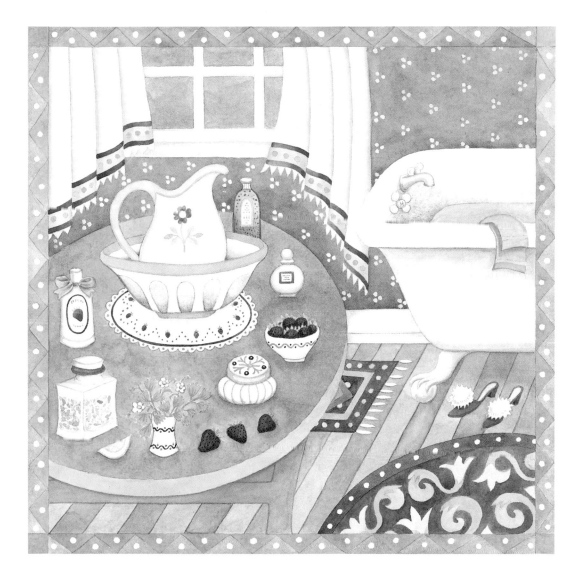

Strawberry Anti-Wrinkle Mask

With a mildly astringent effect, this mask helps to tone and smooth the skin, removing wrinkles.

1 tablespoon mashed strawberry pulp
1 tablespoon raw honey
1 tablespoon plain yogurt

In a small bowl, stir together all ingredients. Apply to clean, damp skin, avoiding delicate eye area. Leave on for 10 to 15 minutes, rinse thoroughly with tepid water, and pat dry.

Makes 1 application

Softening Strawberry Face Pack

This has a regenerating effect on skin, helping to plump out a dehydrated complexion and leave the skin satiny smooth.

1 tablespoon mashed strawberry pulp
2 tablespoons cooled mashed potatoes ➤

1 tablespoon milk
Warm chamomile tea, for rinsing

In a small bowl, mix together strawberry pulp, potatoes, and milk to make a paste. Smooth over clean, damp skin, leave for 30 minutes, and rinse off with warm chamomile tea.

Makes 1 application

Creamy Strawberry Cleanser

This very simple recipe has a toning effect on oily skin.

4 to 6 strawberries, hulled and mashed
1 ripe peach, peeled, pitted, and roughly
 chopped

1 tablespoon rose water
2 tablespoons whipping cream
Finely ground oatmeal, for thickener
 (optional)

In a bowl, mash together strawberries and peach. Strain through cheesecloth into a small bowl to obtain 2 to 3 tablespoons of juice. Whisk juice with rose water and cream. If desired, add oatmeal to thicken mixture. Smooth cleanser over face and throat, leave for a few minutes, and rinse off with tepid water.

Makes 1 or 2 applications

INDEX

Appetizers, *25-29*
 Hearts, 28
 Kebabs, grilled, 26
Bath, use in, *68-69*
 Anti-Wrinkle Mask, 68
 Cleanser, skin, 69
 Face Pack, softening, 68
Breakfast, *35-38*
 Bagels, 36
 Omelet, 38
Cakes and Tarts, *45-53*
 Cheesecake, 47
 Hazelnut Crust, 48
 Tart, yogurt, 49
Chocolate, *54-57*
 dipped, 55
 Fondue, chocolate, 56
Desserts, *45-57*
 Crème Brûlée, 52
 Gelato, 53
 Mousse, 29
 Pistachio Whip, 51
 Soufflé, 50

Drinks, *61-65*
 Daiquiri, 65
 Punch, brandied, 64
 Syllabub, 63
 Yogurt Cooler, 62
Growing, *11-14*
Hazelnut Dressing, *32*

History, 7-9

Measuring, 15

Medicinal Uses, 66-69

Preserves, 58-60

 Rhubarb and Raisin Jam, 59

 Red Currant Jam, 60

Salads, 30-34

 Feta Cheese Salad, 34

 Mustard Dressing, creamy, 34

 Pansy Salad, 32

 Rose Ring, 31

Sauces and Relishes, 39-44

 Barbecue Sauce, 42

 Orange Sauce, 40

 Relish, jellied, 44

 Rhubarb Sauce, 41

Serving Suggestions, 17-18

Soups and Compotes, 19-24

 Ambrosia Compote, 22

 Borscht, 20

 Buttermilk Soup, 21

 Fruits of Paradise, 24

Storing, 15